Anya Gallaccio

CHASING RAINBOWS

ANYA GALLACCIO

TRAMWAY | LOCUS +

MCMXCIX

Published by Tramway and Locus + to coincide with the
Tramway exhibition *Glaschu* by Anya Gallaccio at the Old Court
House, 191 Ingram Street, 11 March – 25 April 1999

TRAMWAY
25 Albert Drive, Glasgow G41 2PE, Scotland

LOCUS +
Room 17, 3rd Floor Wards Building, 31–39 High Bridge,
Newcastle-upon-Tyne NE1 1EW

ISBN 1 899 551 15 8
Second Printing

Publication © Anya Gallaccio, Andrew Nairne, Tramway and Locus +
Essay © Ralph Rugoff
Photographs © Edward Woodman, Steve Guest, Jon Bewley,
Simon Herbert (© Locus + archive), Mike Sweeney, Shigeo Anzai,
Hugo Glendinning, Giorgio Sadotti, Robert Wedemeyer, Daniel
Spehr, Jean Brasille, Manfred Grade, Anya Gallaccio, Steve White,
Torstern Lauschmann

Designed and typeset in Aries by Dalrymple
Printed and bound by BAS Printers Ltd

All photographs, unless otherwise credited,
were taken by Anya Gallaccio

Preface

Among Britain's most impressive younger artists, Anya Gallaccio is at the forefront of the 90s' generation, exhibiting in galleries and museums around the world. But, in contrast to many of her contemporaries, the significance of her work lies less in its conceptual origin than its conceptual impurity. Her installations are like wonderfully unreliable experiments, in which a sense of what should happen is constantly subject to what is happening, as materials such as chocolate, ice and flowers grow, decay, melt, or otherwise change.

Generous and open in intention, at the heart of Gallaccio's art is the viewer, whoever that may be. The viewer sees, touches, hears, smells, walks upon the work, contributing to and participating in its richness and complexity.

Chasing Rainbows is the first publication to document a selection of Anya Gallaccio's work of the past ten years. Co-produced by Tramway and Locus +, it coincides with the Tramway exhibition *Glaschu* taking place at the Old Court House, Glasgow, the artist's first exhibition in Scotland.

We are especially grateful to Andrew Nairne for working with us on both this publication and the Glasgow exhibition, to Ralph Rugoff for his illuminating essay and to the Henry Moore Foundation and the Arts Council of England for their generous financial support. Most of all, we would like to thank Anya Gallaccio for her unstinting commitment and energy over the past two years in realising this publication and both the Hull and Glasgow projects.

Alexia Holt *Tramway*
Jon Bewley and Simon Herbert *Locus +*

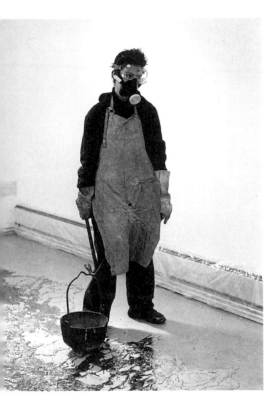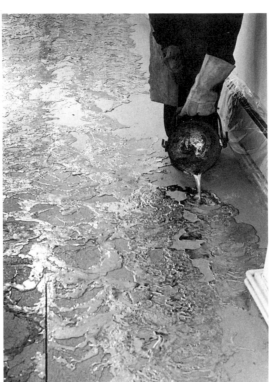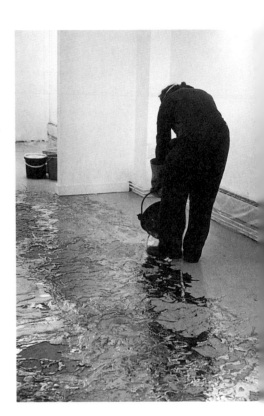

Leap of Faith

Catalogue essays are usually written as though they were meant to be engraved in stone. Sombre and weighty affairs, they aim to fix an artist's place in the flux of history, to carve out a permanent niche for her work. It would be easy to do all this for Anya Gallaccio, but her artwork deserves better − or rather, the memory of it does. Because after over a decade of creating exhibitions, Gallaccio has virtually nothing to show for it. Her many installations and evanescent sculptures have ended up not in the permanent collections of museums and art connoisseurs, but in the skip. Only a few traces and snapshots remain as proof that she has produced anything at all, and these are inadequate as evidence. So in the end, her work lives on only in the idiosyncratic museum of our memories − a house of uncertain repute renowned for its faulty storage systems.

In the spirit of her art, this essay would ideally self-destruct like the message handed to the *Mission Impossible* team at the start of each episode in their TV series. As you read this text it would slowly decompose, falling apart in your hands and leaving only a few faint ink stains. There would be no book to find shelf-space for, no document for the archive. When you had perused it to your heart's content, you would walk away with only what you could carry in your head.

Travelling light is Anya's *modus operandi*. Zigzagging across the globe − alighting in Tokyo, Los Angeles, Rome, Brussels, Zurich, Vienna, now Glasgow − she stops long enough to set up a show and then moves on, leaving the clean-up job to others. She is nomadic not simply in this literal sense, however, but conceptually as well: like a moving target, her work sidesteps facile attempts at defintion, eludes the art critic's pre-existing categories. To gain some idea of how mobile and varied her practice is, consider this inventory of her working materials: lead, salt, ice, glass, rags, kettles, barbed wire, graphite, stones, chalk, candles, carpet, chocolate, flowers, vegetables, blood, urine, semen, and jelly beans. Many of these materials she has used on only one or two occasions before searching out the next item on her unconventional, and continually expanding, shopping list.

Carrying a bucket of hot lead in one hand and a bouquet in the other, Gallaccio treks along the edges of various aesthetic territories, continually crossing borders and never

settling. Her nomadic impulses have led to installations created in public parks, abandoned swimming pools, beaches and harbours, boiler rooms and forests. Even in the confines of a gallery, her work shows up in unpredictable places: on a skylight; in a window frame; rubbed into the floor; or like the rainbow she unveiled last year, hovering in thin air. In the rear-view mirror of her art one catches strange glimpses of the past – fleeting references to arte povera, colour field painting and Minimalism (less obviously) as well as Turner, Pollock and even Piero della Francesca – but Anya has steadfastly remained an artistic bachelorette, unwedded to any single school or approach.

Tracking the aesthetic parameters of her practice is, understandably enough, a daunting, not to say futile, task; one charts spiralling lines of development only to find that they splinter off in radically different directions, veering out of reach of easy generalizations. Perhaps the only place to begin, then, is the beginning – or rather, to begin where the artist herself began: on the floor. Since 1988, when she first publicly exhibited as part of the group show *Freeze* (organized by Damien Hirst at a warehouse in London's Surrey Docks), Anya has regularly been placing her art underfoot, as if trying to trip up our expectations. This is not to say that she has avoided verticality in her art – she has not – but the number of low-lying or utterly horizontal works she has created is significant enough to merit close attention. By getting down on the floor with her, we may find a way to share her unusual perspective.

For *Freeze*, Gallaccio poured hot molten lead across the floor of the exhibition space, creating a splotchy and dully shimmering rectangle which, in contrast to Richard Serra's hurled and splattered lead pieces from 1969, evinced a craggy yet elegant serenity, not unlike a frozen seascape. Two years later the artist created a much larger rectangle by spreading a ton of Jaffa oranges across a warehouse's vast concrete floor, where the fruit was left to rot and fill the space with its potent scent. For *tense II*, made in 1991, Anya arranged a group of unfixed photographs on the floor, placing them beneath a skylight so that the images would slowly fade from view.

Waterloo
1 ton of lead poured in a rectangle on the floor.
Installation: *Freeze*, Surrey Docks, London, 1988

Photo: Edward Woodman

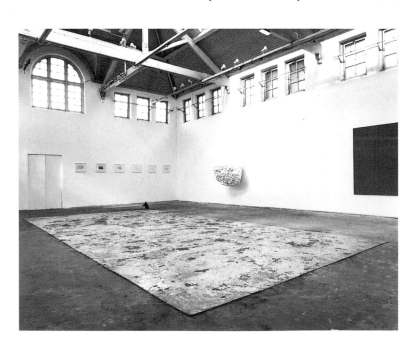

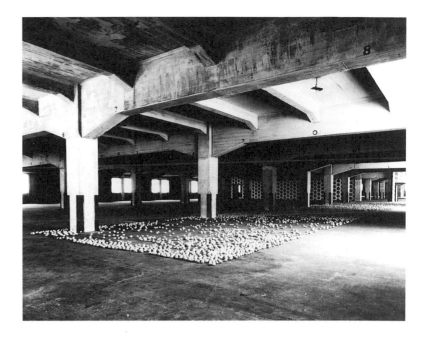

Her first pieces using cut flowers – the material for which she initially became known – were also horizontal floor works. *preserve (cheerfulness)*, 1991, a six-foot-square rectangle of yellow and green rows, consisted of 8,386 narcissi pressed between panes of glass on the floor. Similar pieces made in the same year employed gerbera daisies and sunflowers, and in 1992 Gallaccio carpeted the elegant upstairs gallery in London's Institute of Contemporary Arts with 10,000 red roses lying on a bed of thorns – a gesture redolent of a fantastic, or possibly even grotesque, romanticism, as obscenely overbearing as the aroma that filled the galleries.

This penchant for laying her art on the ground has continued up until the present, including a 1997 project which involved replanting the lawn of London's Serpentine Gallery with a mischievous array of common vegetables and flowers recalling the many former uses of Kensington Gardens. One consequence of this low-down method is that it forces us to change the way we look: unlike a standing sculpture or wall-hung canvas, a floor piece cannot be viewed from a distance; it demands that you come near, and if you want to examine it more closely, you have to crouch or squat. Horizontal placement on the floor creates another somewhat disarming effect: it scrambles our notions of top and bottom, and wreaks havoc with traditional categories of visual order.

There is also a slightly modest quality to this work's low-profile posture, as if it wished to be barely noticeable, to maintain an inconspicuous presence in spaces designed for conspicuous display. Its horizontality effectively de-emphasizes the visual field in which we typically locate art; or, to put it another way, it leads us away from our preference for sight over other senses. While her floor pieces are certainly meant to be looked at, they frequently lead us (often by the nose) to other routes of interaction and engagement. Many of these artworks boast significant olfactory and tactile components – the complex perfumes of decomposing flowers, the surprising sensation of walking across a gallery covered with 2,000 kilos of white textile rag – and in appealing to us in this way they

tense
1 ton of oranges and silk screen on paper
Installation: East Country Yard Show, Surrey Docks, London, 1990

indirectly question the virtues of a sensory hierarchy in which vision rules supreme.

Freud, in fabricating one of his more mythical theories, linked the dominance of sight to our upright posture, suggesting that when we still moved on all fours smell and touch played far more important roles in our perception of the world. Whether or not this theory is historically accurate, it calls attention to the different orientation that characterizes the lying-down part of our lives and to what critic Leo Steinberg referred to as 'our other resource, our horizontality, the flat bedding in which we do our begetting, conceiving and dreaming.' For Steinberg, horizontality related to 'making as the vertical of the Renaissance picture plane related to seeing.'[1]

1. Steinberg, Leo, 'Other Criteria', in *Other Criteria: Confrontations with Twentieth-Century Art* (New York, Oxford University Press, 1972) pp.55–91.

Gallaccio's interest in 'getting down' with her art suggests a similar preoccupation. If sight is the most abstract sense and the one which allows you to maintain your distance, Gallaccio's work gets underfoot as a means of entangling us and forging a more intimate relationship. Many visitors to *red on green*, her ICA installation, ended up bending down and pressing their noses into her carpet of roses, and in other installations in which she has covered a gallery floor with one material or another – coins, salt, a veneer of graphite – viewers have either spread the material with their feet or altered it by leaving footprints and other marks.

Works such as these directly suggest that art is a collaboration between spectator and artist. Rather than a system in which an audience admires a final product that showcases an expert's skill and finesse, Gallaccio's entire practice involves a shift away from the creator's traditionally egocentric involvement with his chosen media. Jackson Pollock's poured and splattered canvases, as well as the 'process art' of his various postminimalist descendents such as Barry Le Va and Robert Morris, typically present a kind of forensic record of the artist's interaction with his materials; Gallaccio's approach, on the other hand, often involves setting up a situation in which a material process outside her control slowly unfolds over time. As Michael Archer has observed: 'In art of this kind beauty is not engineered, fashioned, crafted, but it is ushered in, allowed to develop.'[2]

2. Archer, Michael, *Anya Gallaccio*, exhibition catalogue (Galerie Krinzinger, Vienna, 1993)

This process is probably most spectacular in the many pieces Gallaccio has made employing cut flowers, usually either framing them within glass panes or linking them in daisy chains which are then draped and festooned across an exhibition space. Like the still life vanitas of Old Master paintings, these works have little to do with an appreciation of natural beauty; indeed, Gallaccio has remarked that she regards gerberas as a kind of pop ready-made or found object, an instantly recognizable image not unlike a child's

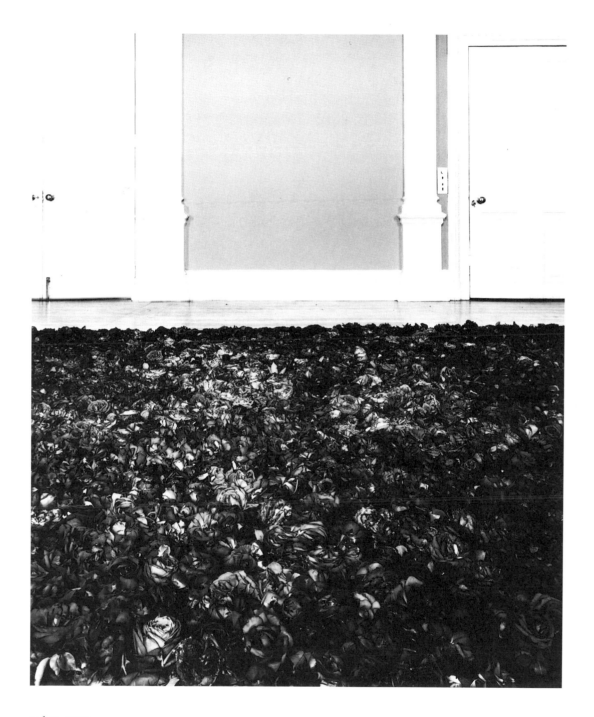

red on green
10,000 fragrant English tea roses, heads laid on a bed of thorns
Installation: ICA, London, 1992

Photo: Edward Woodman

drawing of a daisy. Scentless and mass-produced all year round as disposable commodities, there is in fact little that is 'natural' about gerberas. Yet, like all organic matter, they inevitably decay.

In the vanitas tradition of painting, a bouquet of fresh flowers, captured at the height of their effulgent radiance, served as a visual shorthand for the impossibility of sustained perfection and the inevitability of mortality and loss. Claude Monet's famous paintings of his carefully cultivated lily pond – the most ambitious of which were dedicated to the fallen soldiers of World War I – depict a lugubriously murky space of drowned beauty. But Gallaccio's decomposing flowers do not conjure death and extinction so much as they engage us as witnesses to complex transformative processes. Trapped behind glass, which accelerates their decomposition, her floral compositions move from being brightly coloured and coherent tableaux to fascinating factories of change: mould blossoms, tiny flies appear and depart, sap drips and oozes, and humidity fogs the glass while the flowers themselves turn hard, brown and crispy, like petrified bog people. These are still lifes that do not stand still.

The glass frames serve an ambiguous role in these works: a mediating barrier, they suggest giant scientific slides, and at the same time, picture frames which lend the wall-mounted pieces a painting-like demeanour. They also conjure the museum vitrine's function of protecting and preserving, except that Gallaccio's containers are imperfectly sealed, and invariably suffer leakage of one kind or another. In her wall-mounted pieces, the stems of captured flowers poke out from the bottom of their container, and as they desiccate a handful inevitably drop and fall to the floor like crumpled casualties, wounded escapees from the glass grid. Hers is not an aesthetic of control, but of control's failure, inviting us not to contemplate a cultural dead-end so much as the disconcerting and chaotic beauty produced by decomposition, that dynamic engine of change. They return us to Marx's aphorism (often cited by the Surrealist writer George Bataille) that 'in history, as in nature, decay is the laboratory of life.'[3]

3. Karl Marx quoted in Polizzotti, Mark, *Revolution of the Mind: The Life of André Breton* (New York, Farrar, Straus and Giroux, 1995) p.319

Gallaccio's mutable flower pieces defy any illusion that we, as spectators, are privy to a transcendent or authentic experience – there is no true moment, no definitive point of view, for our encounter with this art, as the work we witness today will have changed in a week's time, and ultimately remains as elusive and changeable as that mysterious entity, the self. This fugitive quality is compounded by the fact that these pieces – like much of Gallaccio's art – are destroyed after they have been exhibited (unlike most artworks,

Anya's are archived with two sets of dates: of destruction as well as creation). Prompted by their precarious 'here today, gone tomorrow' status, we are led to savour their presence in the present, to push aside the clutter of abstractions occupying our minds and to dive into real time, to immerse ourselves in appreciating the details of the moment before they metamorphose into something else.

In a sense, Anya's artworks are events rather than objects. Or perhaps, more accurately, they constitute a hybrid combination: performative objects that enlist us in elliptical slow-motion dramas. Loose narrative structures inform not only her pieces utilizing organic material, but many of her other installations as well, beginning with 1990s' *Prestige*, a chorus of twenty four whistling kettles which the artist arranged in the central chimney of the defunct Wapping Pumping Station. In this case the narrative structure was enacted by the viewer's approach: the kettles' plangent whistling could be heard from the train station a quarter-mile away, and as one approached the pumping station the sound gradually grew from an indistinct background noise to a nagging and insistent shriek. By the time one reached the chimney, it had become unbearably piercing, a wailing chorus that suggested rage and hysterical mourning.

The staging of her installations – how the viewer's approach is orchestrated, which elements are seen (or heard or smelt) first – is of the utmost importance to Gallaccio, who sees her work as comprising not just the material artefacts she has fashioned, but also the objects and space around it, the entire theatre of operations, as it were. In some instances she sets things up so that you move through a work like a tracking shot in a film: for *chrematis*, 1994, an installation in which she papered cracks in an empty Tijuana pool with gold foil chocolate wrappers, visitors initially glimpsed the work from outside the pool, then descended into its waterless turquoise depths, experiencing the silence and stillness therein while slowly walking towards the deep end, where the back wall rose above you like a dominating wave of colour.

An installation like *chrematis* cannot be taken in with a single glance, but has to be experienced over time and from changing points of view – characteristics historically associated with Minimalist art, and specifically singled out by Michael Fried in his famous critique. Writing in 1967, Fried championed a type of art in which 'at every moment the work itself is wholly manifest,' and attacked Minimalism for demanding a time-based experience which was 'paradigmatically theatrical.'[4] His warning cry against theatricality was largely unheeded, however: if temporality was implicit in Minimalism, it soon

4. Fried, Michael, 'Art and Objecthood', *Artforum* 5, no.10 (June 1967)

became an explicit part of the vocabulary used by performance and conceptual artists, as well as many associated with arte povera, who created site-based works of limited duration – a tradition to which Gallaccio is an heir.

But Gallaccio, who worked in the theatre as a dresser before attending art college, has extended the theatricality of Minimalism in ways that dissolve its macho core, most notably in *intensities and surfaces*, 1996, a thirty-two ton sculpture commissioned, appropriately enough, by the Women's Playhouse Theatre. A massive sculpture which required a team of twenty assistants to build, *intensities* mimicked the Minimalist penchant for serial and box-like structures, but rather than using industrial materials it was constructed by

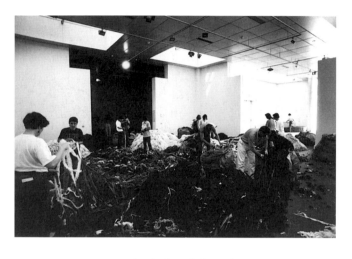

Installing *recover*, for
Life Size, Prato, Italy,
1992

stacking 250-pound blocks of ice, which were then allowed to melt over a three-month period. Because the artist had buried rock salt in the heart of her ice stack, the structure corroded in unpredictable ways, enacting a fantastic shape-shifting drama that was reflected in the widening pool of melted water which spread around its base.

There is also a hidden element of theatricality in Gallaccio's work: namely, the mad rush of last-minute preparation required by her event-like art. As in the theatre, its construction is often a communal labour with the artist enlisting the help of friends, assistants and on occasion seeking the expertise of professional engineers or botanists. But for all the frantic activity behind the scenes, it is crucial to her enterprise that the final product looks effortless. Gallaccio may spend ten days on her hands and knees busily rubbing graphite into the floor of a gallery, but the end result has the simplicity of a ready-made.

By concealing her artifice under this cloak of 'naturalness', Gallaccio can more effectively fuse the fabulous and the real – and this is a key strategy in her art. While she works with everyday materials, she tends to do so in absurd and fantastical quantities, littering an exhibition space with 50,000 5-Rappen coins; laying down a bed of 10,000 roses; pouring 11,000 pounds of salt under a barbed-wire installation; spreading ten tons of stones across a pair of galleries. These are the kind of unimaginable numbers associ-

ated with fables and folk tales, and they call attention to a fairy tale-like thread that weaves a wayward path through the body of her work.

Confronted by a chimney filled with kettles that won't stop screaming, a rainbow imprisoned in a darkened room or chocolate walls that recall the gingerbread house of Hansel and Gretel, we find ourselves bewitched by an echo of the fabulous, a sense of spells having been cast and spaces enchanted. But this motif is never handled in a precious fashion: as in true fairy tales, there is no trace of sentimentality in Anya's art, but instead there may be a note of lurking dangers, a sense of portent derived from very real hazards – such as falling blocks of ice, perilously slippery floors, or low-slung branches

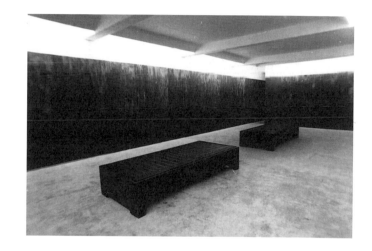

of barbed wire that booby-trap a walk through installation. (The artist herself ended up in hospital after burning a foot while making her poured-lead sculpture *Waterloo*, 1988.)

No dreamy magic realist, Gallaccio is a visionary materialist whose work hums with critical intelligence and displays a keen awareness of local context. When she plants a perfect 8 × 8 metre square of flower-patterned carpet in the middle of a bluebell wood – as she did for 1995's *forest floor* – she offers a wry comment on the factory-like aspect of land management in a so-called nature preserve. *they said there was a paradise way out west*, 1996, a disorienting installation created in San Antonio, Texas and featuring Pollock-like skeins of barbed wire twisting above a salt-covered floor, pointedly evoked, among other things, the militarized border between the United States and Mexico.

And while Gallaccio's projects often *sound* fantastical, they typically seem surprisingly down-to-earth when we encounter them in person. The idea of a chocolate room may call to mind the wondrous realm of fairy tales, but its physical appearance is hardly spectacular, providing nothing more to look at than a few painted brown walls (although their aroma might send a chocoholic's brain into overdrive). This dichotomy is another critical component of the artist's strategy, as her work quietly, but insistently, probes the gap between expectation and reality, exploring situations where our fantasies fail and we are thrown back onto real-time experience.

stroke
Cadbury's Bournville chocolate on card, gallery benches
Installation: Karsten Schubert, London, 1994
Photo: Steve Guest

This is a risky gambit: in a media-driven culture which continually bombards us with perfect images and images of perfection, physical reality frequently seems underwhelming, and many of us may initially respond to such work with disappointment and peevishly blame the artist. Yet rather than make concessions to our desire for spectacle, Gallaccio instead has chosen to make art that is less and less tangible: *Two sisters*, 1998, a six metre high column of chalk and plaster set afloat in the Hull estuary, was eroded by tides until it completely dissolved, leaving nothing for the trash man to cart away.

Nor does Anya pander to the possessive fantasies of collectors. Unlike many creators of emphemeral works, Gallaccio has refused to sell photographs of her art because, however beautiful or seductive it may appear in photos, images cannot convey the complex and varied sensations that arise from encountering the actual work. They fail to capture what engages and interests us in that encounter – the emotional and sensory responses triggered by the work's material attributes, and our own active role unfolding and engineering her art's latent narratives. A picture of a brown wall is virtually meaningless compared to the personal confrontation which might very well end with one of us stroking and licking its chocolate-coated surface.

And no photograph can convey the possibility of failure that hovers over each of Gallaccio's installations, which are created in public spaces without the safety net of trial and error enjoyed by a studio-based artist. Going against the grain of an art world which rewards those who deliver guaranteed products, Anya's work involves unpredictable processes for which, like an improvised theatrical production, there can be no dress-rehearsal. It is not a question of her courting failure, but of her insistence on creating 'live art' that requires risks.

Classically, art objects are meant to provide fixed points of reference. They are meant to be tougher than we are. As Bruce Chatwin has observed: 'Things are the changeless mirror in which we watch ourselves disintegrate. Nothing is more ageing than a collection of works of art.'[5] Yet by mirroring our own precarious physicality, Gallaccio's art does not age us but engages us, encouraging a leap of faith into the open spaces of the present, that paradoxically timeless moment which is forever changing. There are enough things in the world already, her approach implies, and perhaps it is only by giving up our lust for possession that we can begin to recognize and pay attention to the quietly outrageous metamorphoses in process under our noses and under our feet.

RALPH RUGOFF

5. Chatwin, Bruce, *Utz* (London, Cape, 1988) p.13

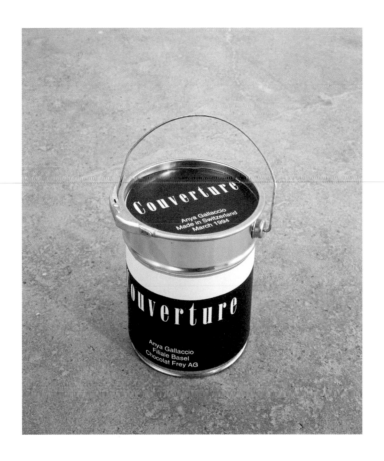

couverture

Plain Couverture chocolate, coconut oil in aluminium can,
silkscreen on paper, 1994

photo: Steve White

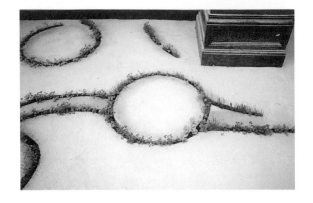

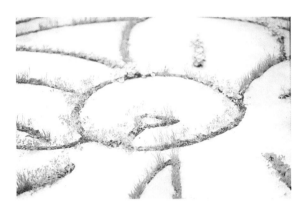

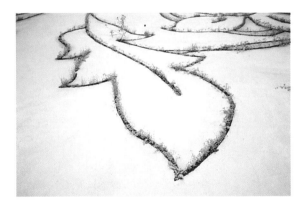

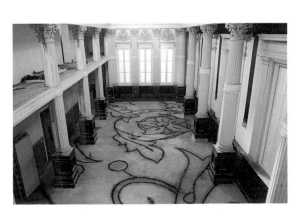

Glaschu
planted green line set in concrete floor
Lanarkshire House, Glasgow, 1999

photos: Torsten Lauschmann

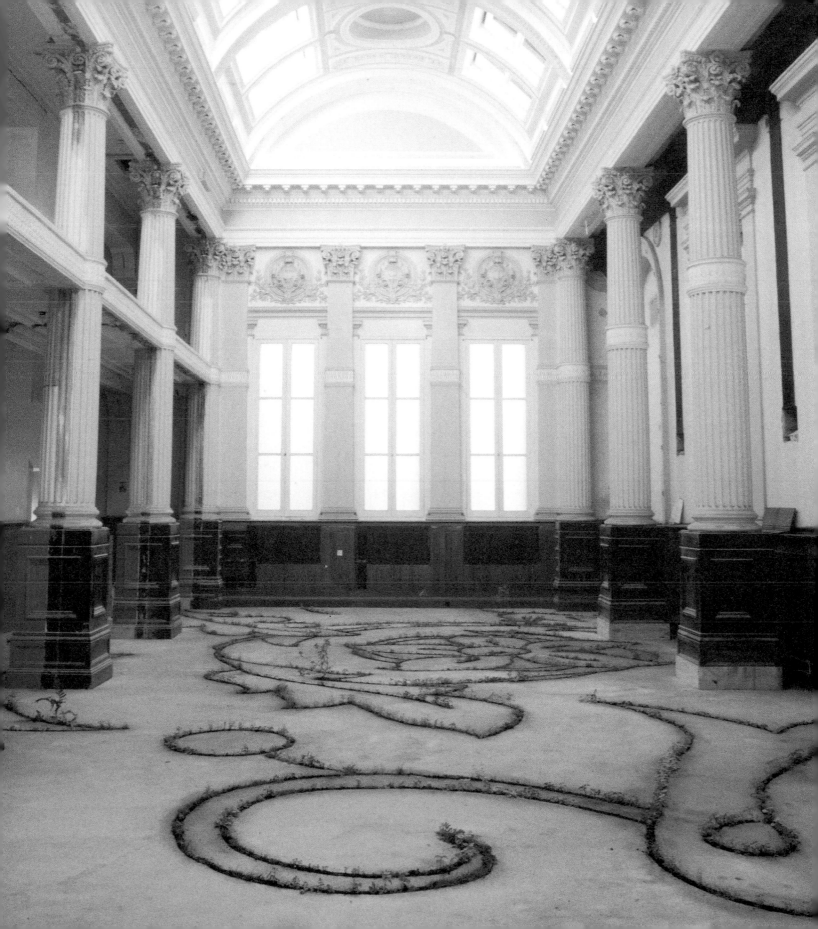

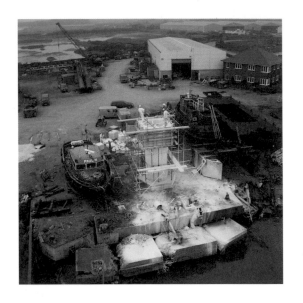 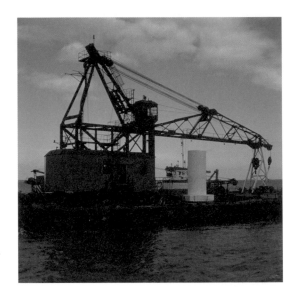

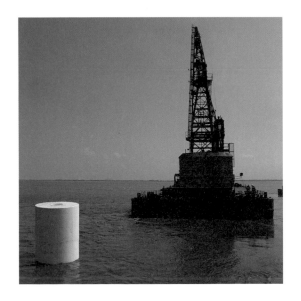 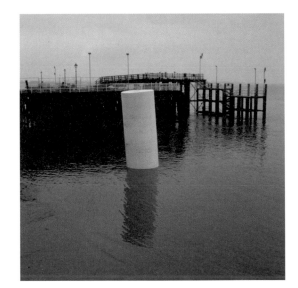

Two sisters

60 ton column of locally quarried chalk bound
with plaster, 6 × 2.5m
Minerva Basin, Hull, 1998

Photos: Jon Bewley, Simon Herbert, Mike Sweeney

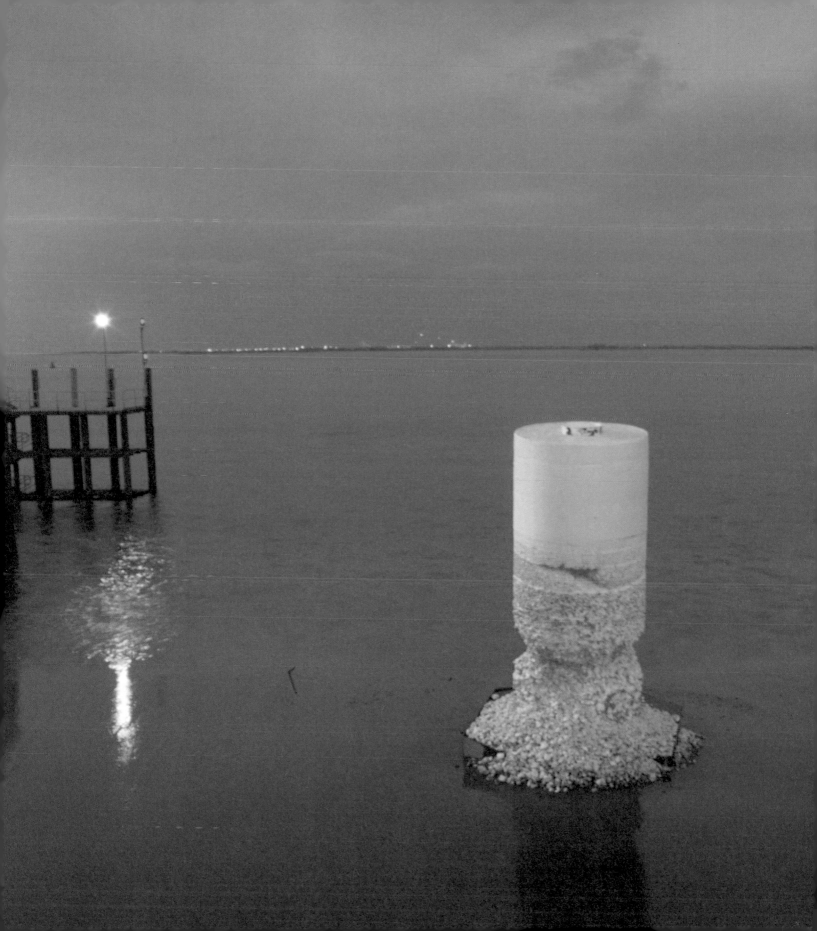

Chasing Rainbows

Glass beads and light
Made for Delfina, London, 1998

Photo: Shigeo Anzai

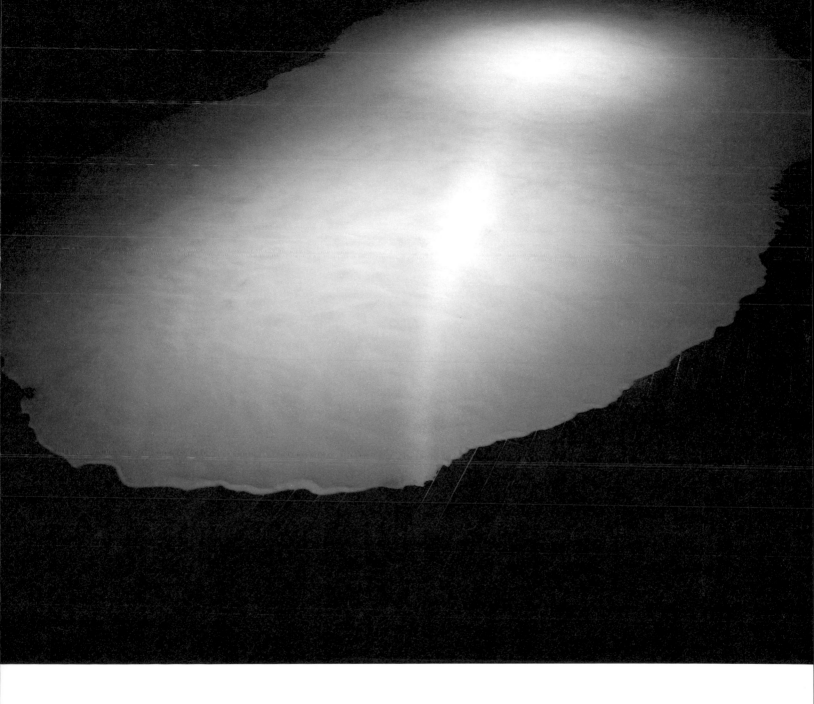

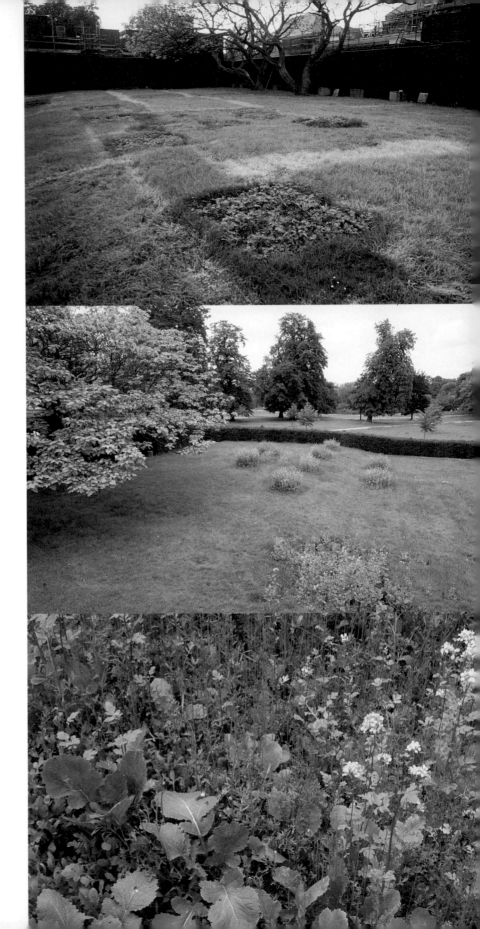

keep off the grass

Common vegetable and flower seeds, sown
in the scars left on lawn by other sculptures
Serpentine Gallery Lawn, London, 1997

Photos: Hugo Glendinning

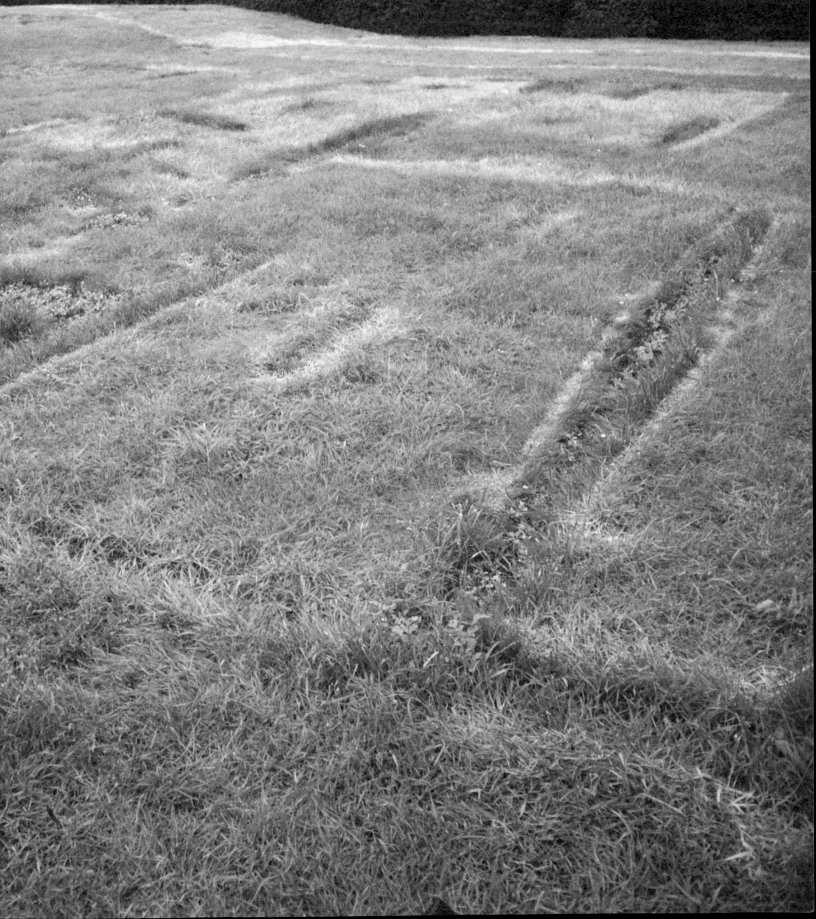

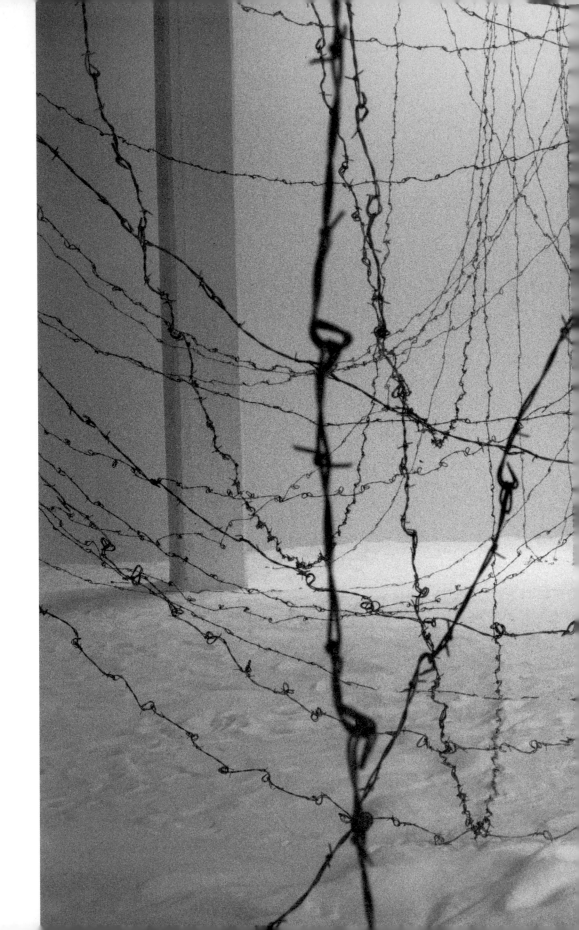

they said there was a
paradise way out west
Barbed wire and salt
Art Pace, San Antonio, Texas,
1997

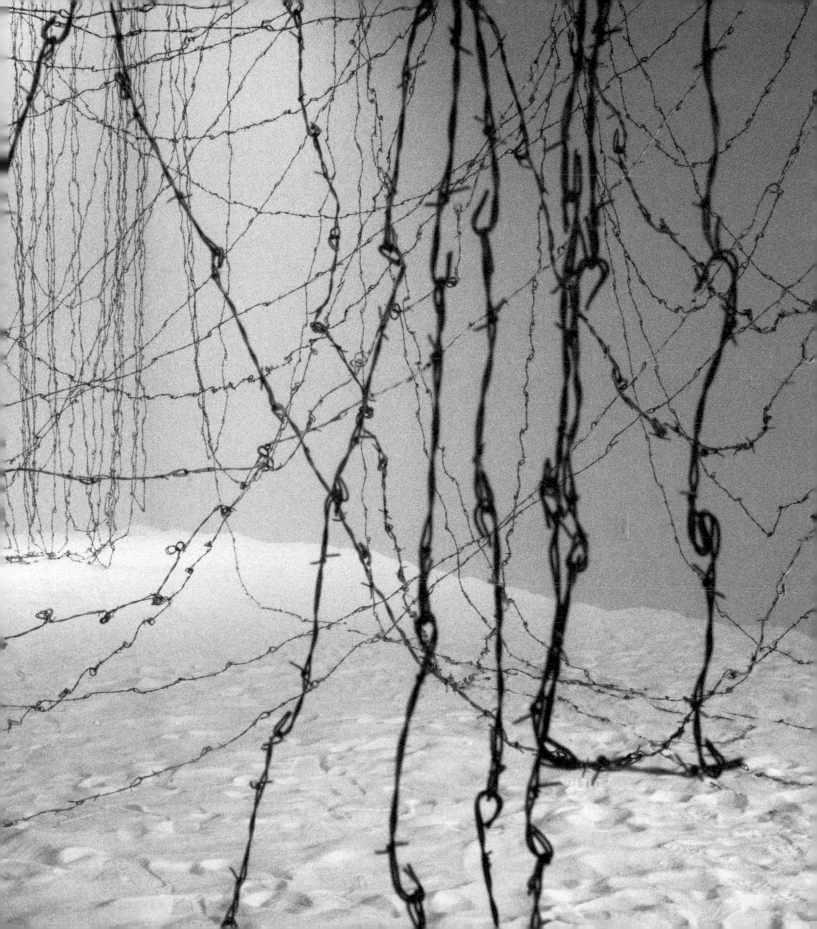

chrematis

Gold foil chocolate wrappers, Pulmeria, in a derelict pool
Aqua Caliente, Tijuana, Mexico, 1994

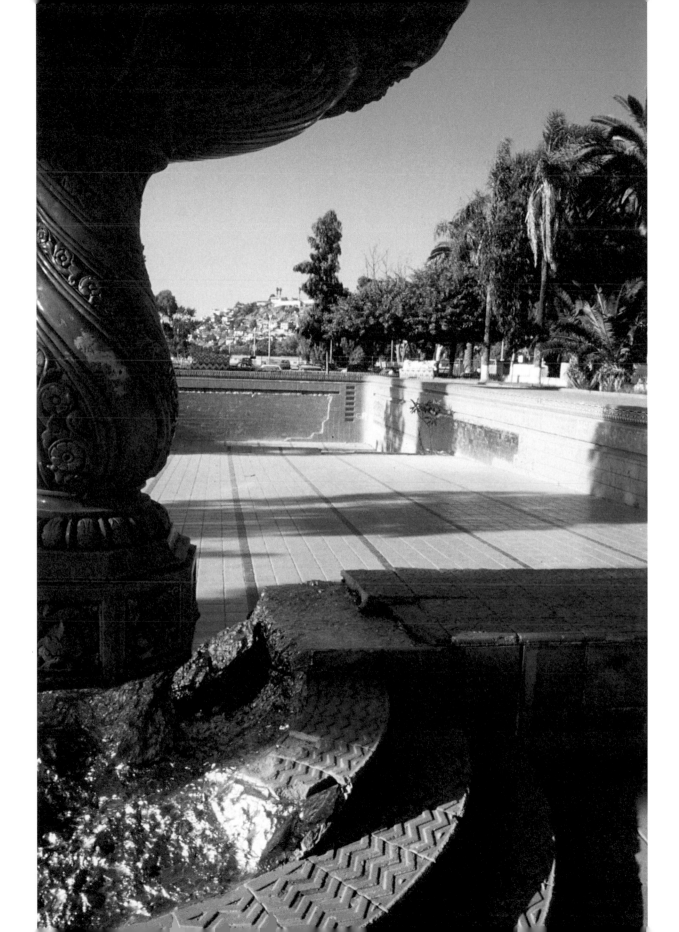

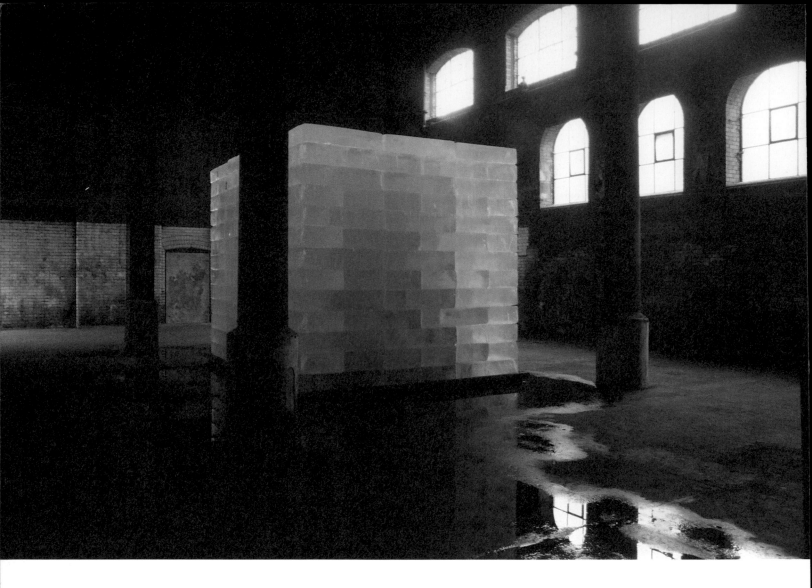

intensities and surfaces

32 tons of ice and a half ton boulder of rock salt,
3 × 3 × 4 m
The boiler room, Wapping Pumping Station, London, 1996

above: February 1996

opposite: March 1996

overleaf: April 1996

head over heals

365 orange gerbera (Barcelona), threaded into a chain
Stephen Friedman Gallery, London, 1995
Photo: Giorgio Sadotti

overleaf

stroke

Plain couverture chocolate and coconut oil
detail of installation, Blum and Poe, Los Angeles, 1994
Photo: Robert Wedemeyer

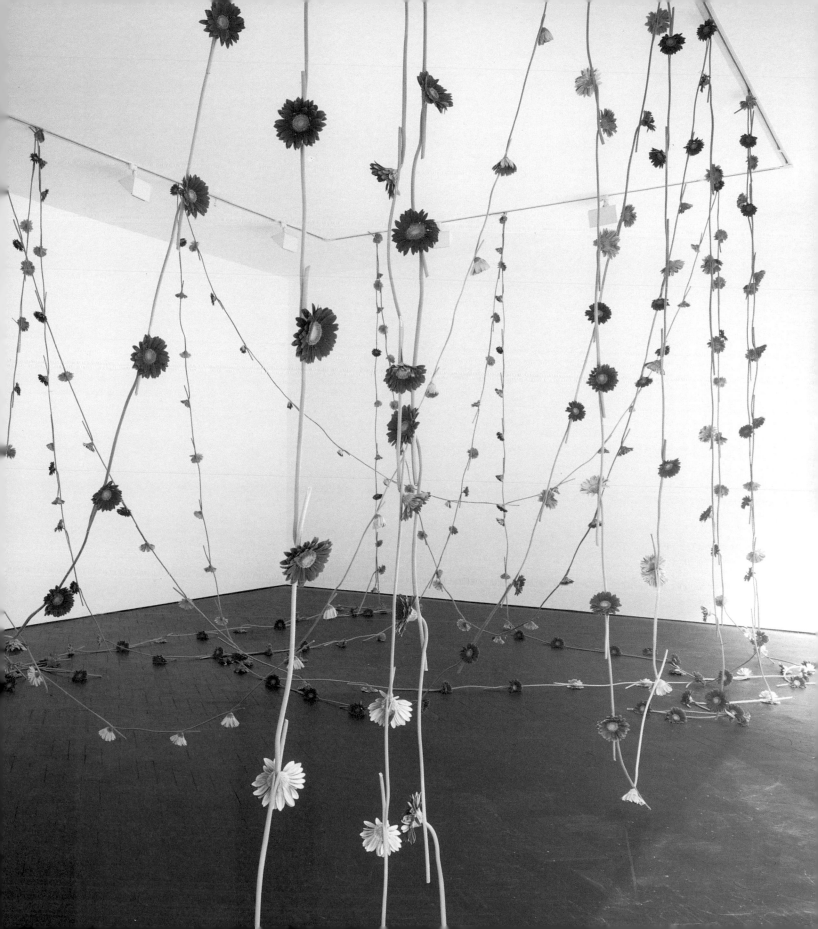

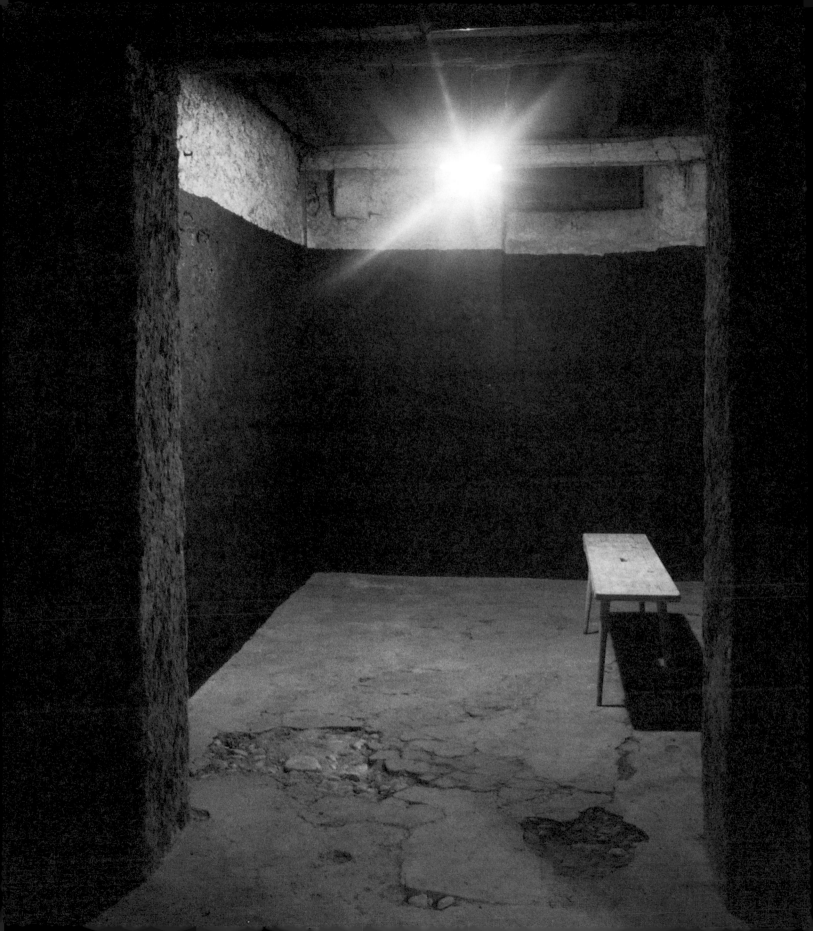

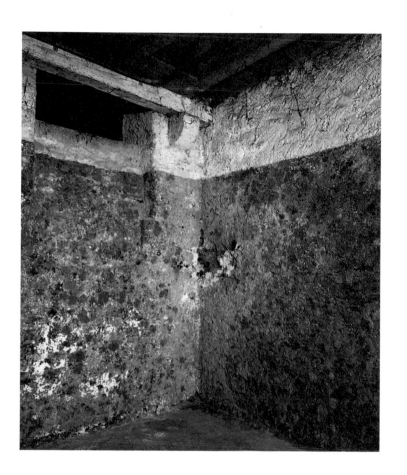
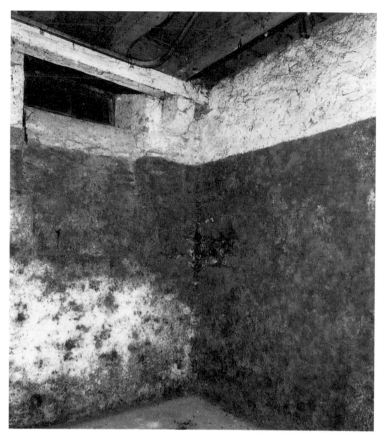

couverture

Plain couverture chocolate and coconut oil painted directly
onto walls in cellar of abandoned house, bench and light
Installation: Filiale, Basel, Switzerland, for Roman Kurzmeyer

opposite: *couverture*, March 1994

above left: *couverture*, July 1994
above right: *couverture*, May 1996

Photos: Daniel Spehr

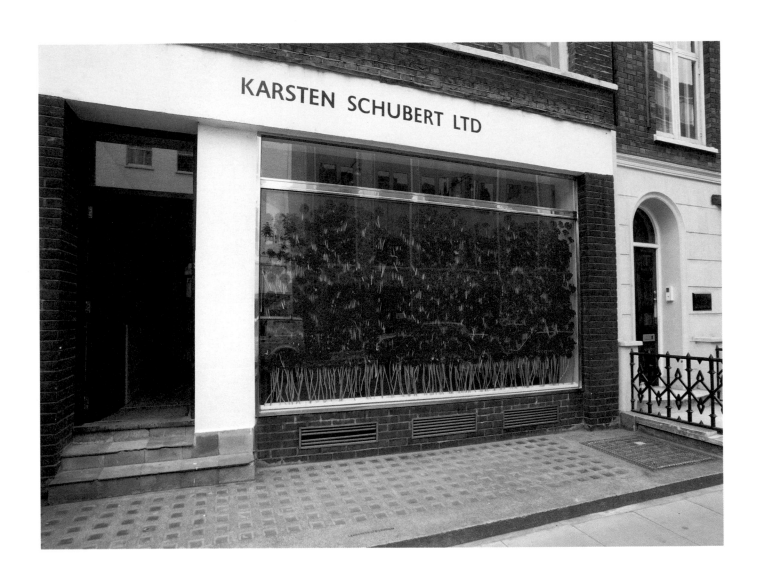

preserve 'beauty'

800 red gerbera (Beauty) pressed between the gallery window and glass

Karsten Schubert Ltd., London, 1991

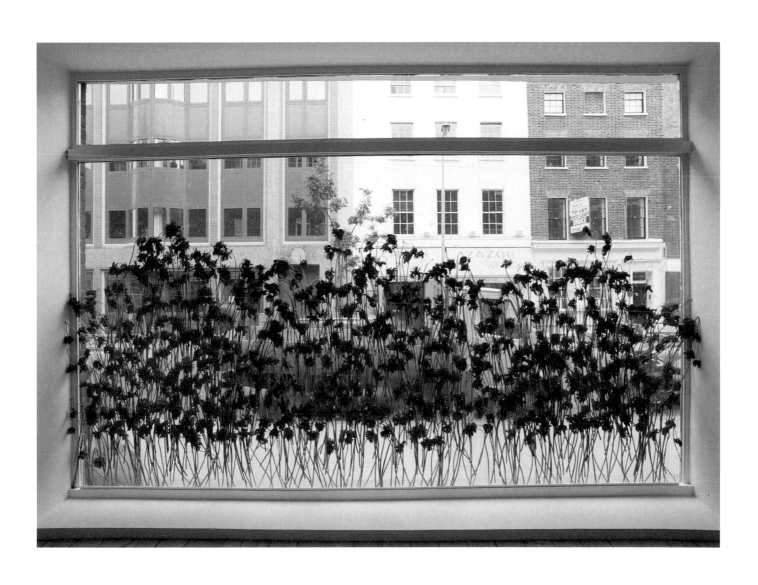

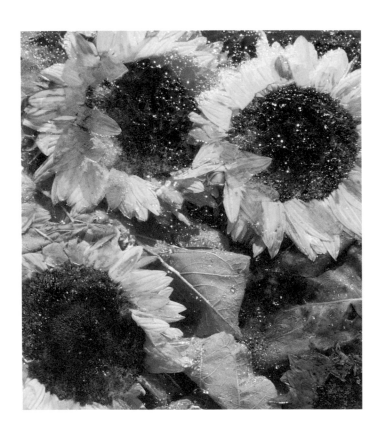

preserve sunflower
101 sunflowers, arranged in rows between two sheets of glass
150 × 150 × 6mm in a room with no daylight
details of installation, Clove Building, London
September to October 1991

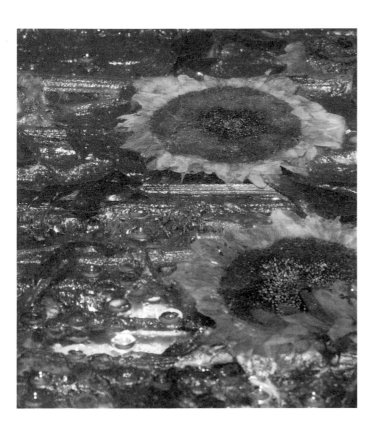 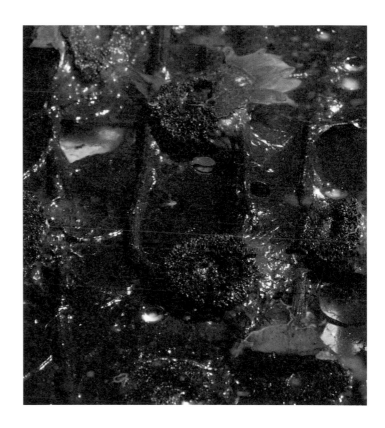

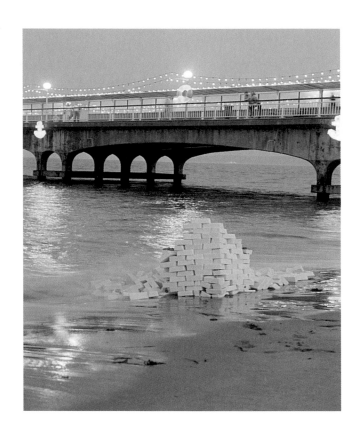

into the blue

One ton of salt bricks on Bournemouth beach
Bournemouth Festival, 1993

photos: Steve Guest

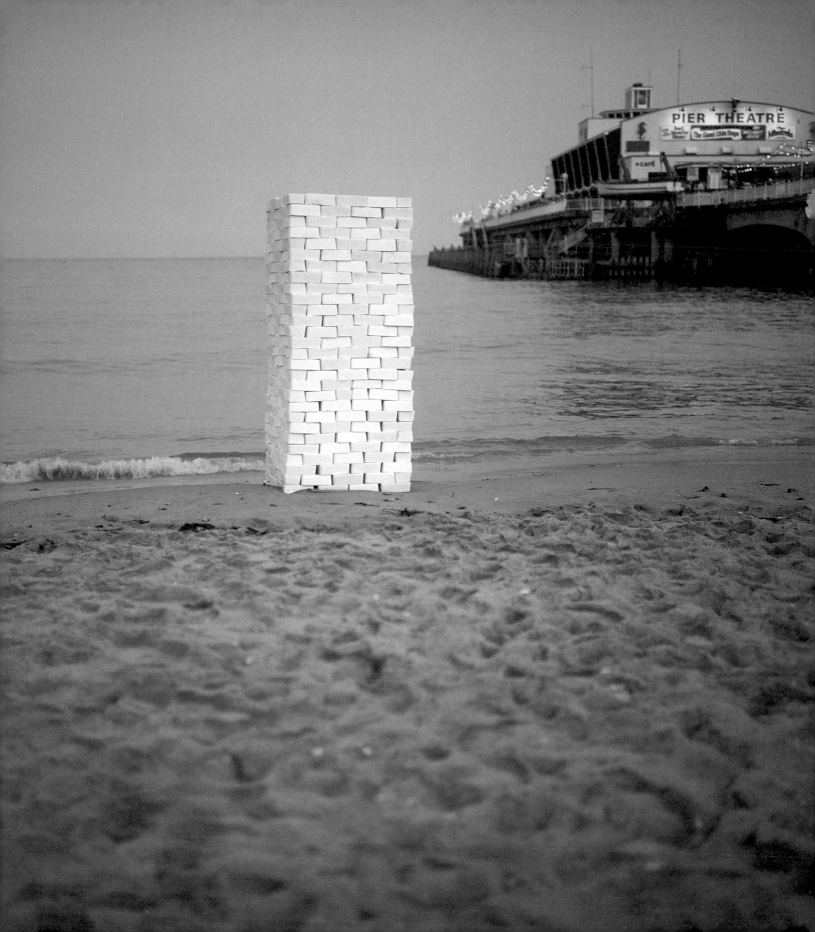

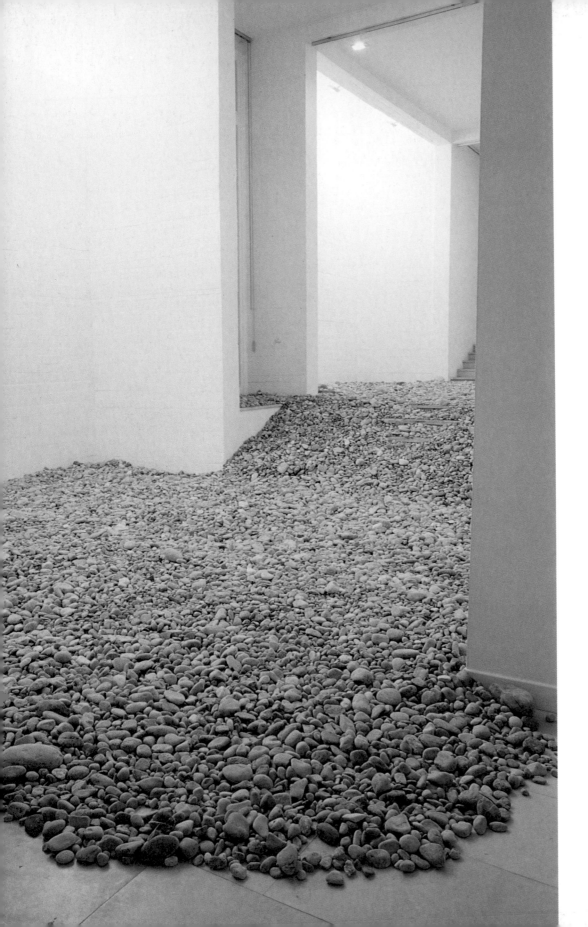

left

concrete

Ten tonnes of stones from Nice
beach, 1230 × 540cm
Villa Arson, Nice, 1993

Photo: Jean Brasille

right

Harvest of the winter months

Graphite powder rubbed into
concrete floor
Galerie im Künstlerhaus,
Bremen, 1996

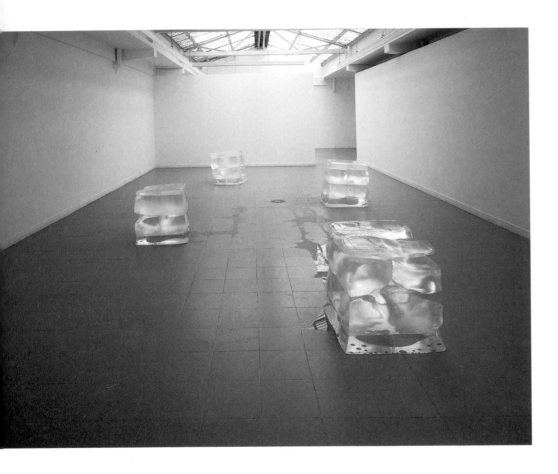
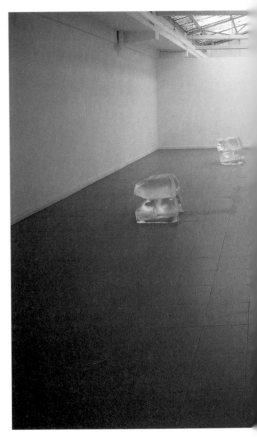

absolute

Four cubes of ice, 100 × 100 × 100cm
Galerie Rodolphe Janssen, Brussels, 1996
Photo: Manfred Gade

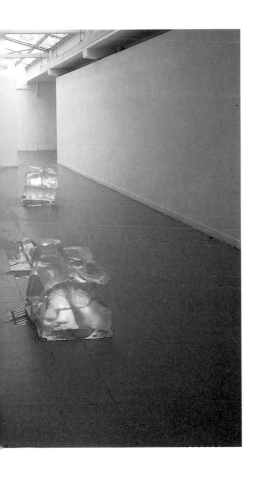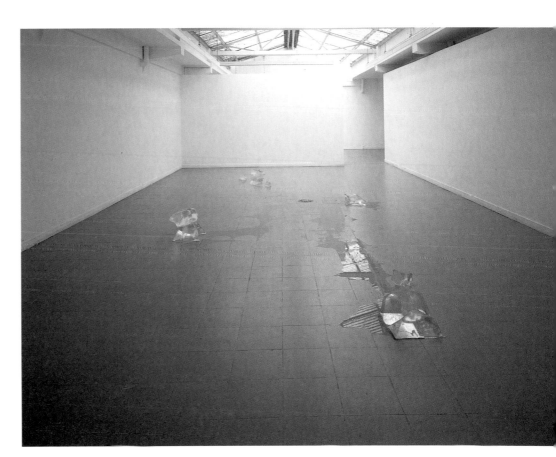

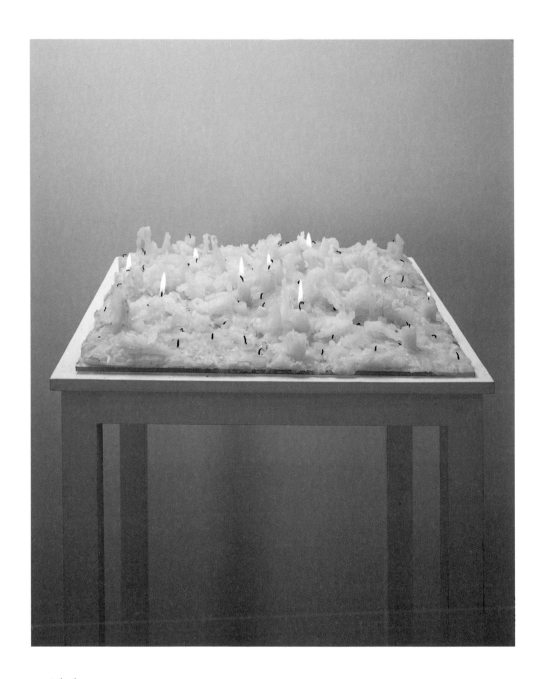

untitled

White candles on glass, 50 × 50cm

Galerie Rodolphe Janssen, Brussels, 1996

Photo: Manfred Gade

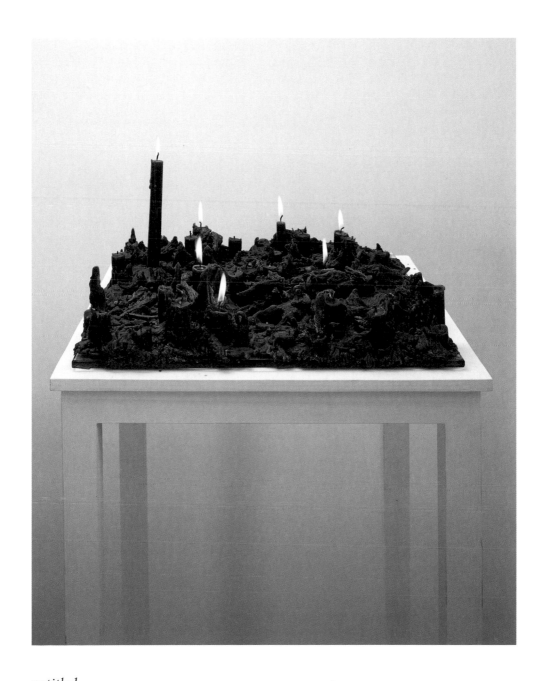

untitled

Black candles on glass, 50 × 50cm

Galerie Rodolphe Janssen, Brussels, 1996

Photo: Manfred Gade

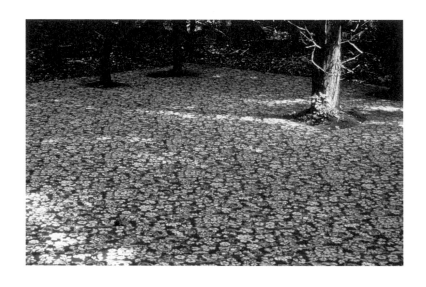

forest floor

Domestic floral patterned carpet, larch and birch trees, 8 × 8m
Chiltern Sculpture Trail, Oxford, 1995

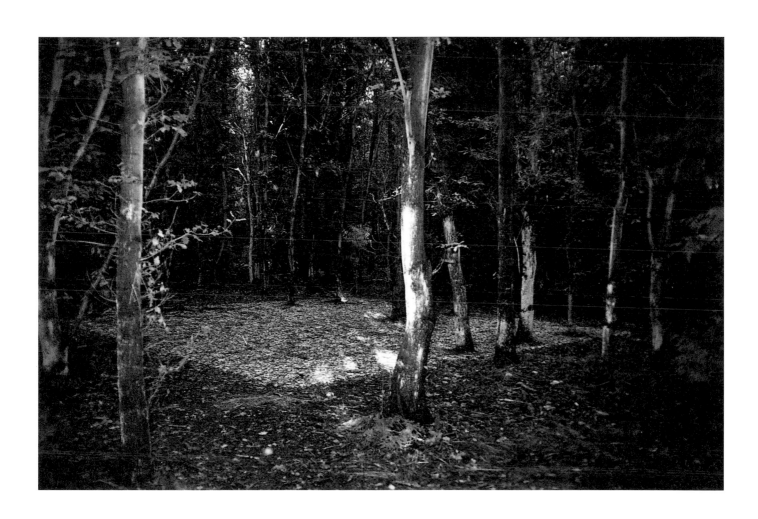

Prestige
21 kettles linked to a compressor
whistling continuously in an
abandoned tower at the derelict
Wapping Pumping Station.
September/October 1990.

Prestige 2
21 different drawing each presenting
0.2 seconds of time from a DAT
recording of 21 whistling kettles,
processed through a computer
programme at Imperial College London
and charted on a graph plotter.
June 1992. This drawing represents
0.2 seconds _343·2_ seconds from the
begining of the tape.

Anya Gallaccio
copyright 1992 Anya Gallaccio
and G-W Press.

Published by G-W Press.

prestige

21 kettles whistling in the tower
of the disused Wapping Pumping
Station, London, 1990
Photo: Edward Woodman

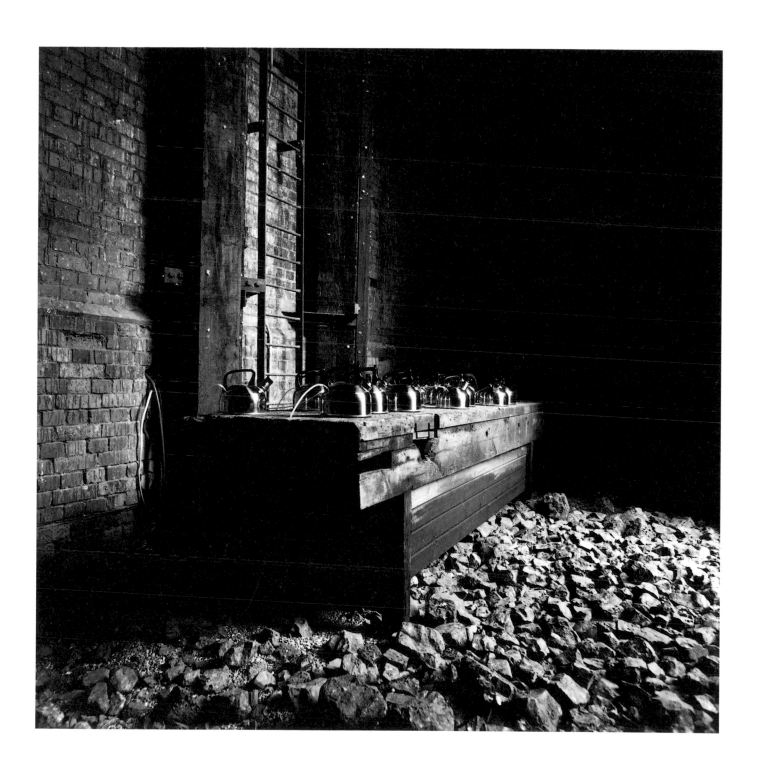

skin deep

apple, gold leaf, etched glass and wood

40 × 20cm, 1998

photo: Steve White

An interview with Anya Gallaccio

ANDREW NAIRNE *In Hull last year you did something rather extraordinary. How did you come to make the work* Two sisters?

ANYA GALLACCIO Locus + were invited by Artranspennine to propose an artist to be part of an exhibition that was taking place across the whole of the Pennine region in the summer of 1998. The brief was to produce works which exposed the region, its people and places. I was sent this huge road map and an AA guide book and had to choose where to make a project. Liverpool and Hull are connected by waterways and are both points of arrival and departure from this island. Hull seemed to be a place that defied definition, geologically and geographically continually shifting. You can actually see the power of the North Sea, the conflicting energies of the tidal fresh and salt waters. The silt in the Humber is so mobile that the port authorities are continually charting and measuring its movement, updating navigational charts every three months. I wanted to see if I could make a work that was effected by the region as well as exposing it.

Much of the land around Hull has been reclaimed from the water. The physical composition was formed during the Ice Age, when the area would have been made up of ice lakes. This marshy land was drained and stabilised by Dutch engineers during the reign of Charles I. The docks were dug out during the eighteenth century, and have been filled back in since then. Now they are building sea walls to protect the city from the advancing tide, and on it goes. The mutability of Hull and the Humber estuary fascinated me. It seemed to be an embodiment of my approach towards materials and my reluctance to fix or make permanent an object to a place.

My idea was to make a structure that would be manipulated by the tidal flow – which would continually modify its shape – something that would be revealed and concealed by water, dissolving and reclaiming it. I hoped that the structure would be plotted onto the navigational charts before disappearing again.

Initially the structure was to be made of layers of different alluvial substances all local to the area. The structure would have been quite discreet, tonally blending in with its surroundings, browns merging with the muddy water, its presence marked by water

spouting through it. In the end, we used a mixture of locally quarried chalk of different grades bound with plaster – materials traditionally associated with making art. I was excited by the paradox – all the effort and energy to make a pristine white structure and then placing it into the dark brown muddy water, to let the salt and the water eat away at the surface and the mud mark and stain it. I was hoping that there would be a building up of marks and mud and a breaking down, dissolving. It was a very brutal object. In that sense, I suppose, it was uncompromising. I didn't try to seduce the public in any way, to make it look beautiful, though actually the surface close up was, but no one could get close enough to see that.

Why was it called Two sisters?

In Holland when there are two similar architectural structures close to each other, they are referred to as two sisters. The coast line around Spurn Head is moving so quickly – in geological terms – that apparently in around two hundred years time some of this mass will have shifted over to Holland – joined Europe. I liked the idea that it had a partner somewhere.

How long was it between your first visit to Hull and when Two sisters *was in place?*

About five or six months I think, not long enough to collect information and resolve the potential problems. That is the nature of working in this way. I am very impractical. I seem to have unrealistic expectations of people and materials. So of course the actual work is a long way from what I imagined. I have all these unresolved projects floating around in my head, and I hope that some day I will have the opportunity to pursue some of those ideas further. I met some brilliant and fascinating people on this project. It would be so wonderful to be able to work with Kim Harrop and the Humber Work Boats again.

The *Two sisters* piece was a very difficult work for me. I had been trying to make things that were less physical, made of less stuff. *Two sisters* weighed around 62 tons. We had to use the biggest working crane on the Humber to lift it into place. I had been trying to find an opportunity to make a rainbow, to work with water and light. It was one of my first thoughts for the Serpentine lawn, and I had hoped to make one for Tramway in Glasgow. A massive wall of water would divide the space, the audience would have to walk through it to enter the gallery – a fairly major intervention into the structure of the space whilst

being visually minimal. You would have to work to see the rainbow, to move around – to get into the right place in relation to the light. You have to believe in it to want to see it. It is all and nothing. It is such a simple pleasure to see a real rainbow, I am always excited by it, and it is so loaded as a symbol.

The rainbow that I made for the gallery at Delfina in London was the perfect solution for the problem that I had set myself. The floor was covered with a puddle of sand, a particular industrial glass bead used for cleaning fine surfaces. The floor in the gallery is concrete painted pale grey, a couple of tones darker than the sand. The space was dark and only illuminated by two spotlights pointed at the ground, so the glass was almost invisible. There was a large pale mark on the floor as if a layer of the paint had been sanded off. If you came into the space and walked along the edge of the puddle a rainbow appeared, hovering across the surface and as you moved so did it, appearing and disappearing depending on where you stood. At certain points it was above the surface and at other moments it was below. But you had to do the work. The experience does not translate into a photograph because of the relation of the light to the floor to see the effect, so you have to make the rainbow with your eyes.

What is happening with your project in Glasgow?

Tramway is closed at the moment for redevelopment, so we decided to find another space rather than let the dates of the show be determined by the builders. Looking through the leaflet for an architectural open day in the city I spotted a description of Lanarkshire House built on the site of a Virginia tobacco mansion. Lanarkshire House was a bank and then the city's High Court and now it will become a bar and restaurant. Stefan King was very enthusiastic that I might use one of the main rooms and it meant that I got to use the place as it was found, before it had been renovated – before any one has seen the space.

It had been the High Court until fairly recently so not that many people would be familiar with the interior. We have made a new floor for the room, using a tiny part of a pattern taken from a carpet in the Templeton factory archive. The pattern is from around 1840, the same time as the building. It is blown up to such a scale that its source is not recognisable, but as you walk across the floor you can determine large leaf and flower forms. The floor is concrete with a living green line cutting through the surface planted with fairly common green plants, things that we take for granted but are not indigenous

59

– which all came from far away. The title of the exhibition is *Glaschu*, the Gaelic name for Glasgow which means 'dear green place'.

Making this show has been very important to me – I am Scottish, I was born here, my parents are Scottish but my great grandparents on both sides of my family are not – on one side Italian and on the other Polish Jews. I think that this is quite common. I was brought up in London since I was three – I don't feel that I belong anywhere. I was interested to see if this was going to feel like coming home, and what that might mean.

I am working on a garden at the moment. So maybe, at last, I will make a permanent piece. The garden as an idea seems to fit perfectly with all my main preoccupations – the garden as palimpsest perhaps, letting the past show through and seeing what happens in the future.

Anya Gallaccio

1963	Born in Paisley, Scotland. Lives and works in London
1984–1985	Kingston Polytechnic
1985–1988	Goldsmiths' College, University of London
1997	Art Pace International Artist's Programme, San Antonio, Texas
1998	Sargent Fellowship, British School at Rome

SELECTED SOLO EXHIBITIONS

1991	Karsten Schubert Ltd., London
1992	*red on green*, ICA, London
1993	Kim Light Gallery, Los Angeles
	Ars Futura Galerie, Zürich
	Galerie Krinzinger, Vienna
1994	*La dolce vita*, Stephania Miscetti, Rome
	stroke, Karsten Schubert Ltd, London
	Couverture, Filaile, Basel
	stroke, Blum and Poe, Los Angeles
1995	Stephen Friedman, London
	Towards the Rainbow, Angel Row Gallery, Nottingham
1996	*Intensities and Surfaces*, Wapping Pumping Station, London (for the Women's Playhouse Trust)
	Ars Futura Galerie, Zürich
	Galerie im Künstlerhaus, Bremen
	Galerie Rodolphe Janssen, Brussels
	A Multiple, Riding House Editions, London
1997	Art Pace, San Antonio, Texas
	Serpentine Gallery Lawn, London
	Blum and Poe, Los Angeles
1998	*Chasing Rainbows*, Delfina Studios, London
	Bloom Gallery, Amsterdam
	Two sisters, Minerva Basin, Hull (for Locus + and Artranspennine)
1999	*Glaschu*, Tramway at Lanarkshire House, Glasgow

SELECTED GROUP EXHIBITIONS

1988 *Freeze*, Surrey Docks, London

1988 *New Year, New Talent*, Anderson O'Day, London

1990 *East Country Yard Show*, Surrey Docks, London

 Next Phase, Wapping Pumping Station, London

1991 Museum of Installation, Site three, Surrey Docks, London

 Broken English, Serpentine Gallery, London

 Confrontaciones, Palacio de Velázquez, Madrid

1992 *Life Size*, Museo D'Arte Contemporanea, Prato, Italy

 Barbara Gladstone Gallery and Stein Gladstone Gallery, New York

 (a group show curated by Clarissa Dalrymple)

 Sweet Home, Oriel Mostyn, Gwynedd

 With Attitude, Galerie Rodolphe Janssen

1993 *Le Principe de Réalité*, Villa Arson, Nice

 Le Jardin de la Vierge, Musée Instrumental, Brussels

1994 *Domestic Violence*, Gio Marconi, Milan

 inSITE,94, MOCA, San Diego; Agua Caliente, Tijuana, Mexico

 Art Unlimited: Multiples from the 1960s and 1990s,

 South Bank Centre touring exhibition

1995 *Chocolate!*, The Swiss Institute, New York

 Bloom Gallery, Amsterdam (with Fortun O'Brien)

 Where you were even now, Kunsthalle Winterthur

 Brilliant, Walker Arts Centre, Minneapolis; CAM, Houston, Texas

 The British Art Show 4, South Bank touring exhibition:

 Manchester, Edinburgh, Cardiff

1996 *Private View: Contemporary British and German Artists, A New Collection for John and*

 Josephine Bowes, The Bowes Museum, Barnard Castle, Durham

 The Pleasure of Aesthetic Life, The Showroom, London

1997 *Pictura Britannica*, MOCA, Sydney, Australia

1998 *Real Life: New British Art*, British Council touring exhibition, Japan

1999 *Prime*, Dundee Contemporary Arts

PROJECTS

1989 *The Return of Ulysses*, Floor for English National Opera, London
1992 *Prestige 2*, published by G.W. Press
1993 *A collaboration with Rosemary Butcher*, Third Eye Centre, Glasgow
 Into the Blue, Bournemouth Festival
 Sarah Staton Supastore, on going editions project
1994 *Shiny Nylon*, George V Docks, Deborah Levy and Kristina Page with W.P.T
1995 *Forest Floor*, Chiltern Sculpture Trail, Oxford
1996 *Be Me*, a project for Giorgio Sadotti at Interim Art, London
1997 *Habitat*, print portfolio
 Screen, Twelve Artists from London, print portfolio, Paragon Press

Acknowledgments

For their invaluable help in realising the exhibition and this publication, Anya Gallaccio, Andrew Nairne, Tramway and Locus + would like to thank:

Stefan King, *Director, King City Leisure*

Justine Gallaccio; Fergus Garrett; Glasgrow, The Hydroponic Company; Jamieson Plasterers Ltd.; Iain Kettles; Julian Kildear; Jim Lambie; Colin Macfarlane; Torsten Lauschmann; Ian Smith, Manager, Queen's Park Nursery; Simon Starling; Stoddard International; and Chris Wond, Scottish Agricultural Centre.

In addition, Anya Gallaccio would like to thank:

Julienne Dolphin Wilding *for insisting that I be myself*

Rita Clare Britten; Glenn Brown; Angus Cook; Roger Cook; Tacita Dean; Sarah den Dikken; Delfina Entrecanales; Martin Gayford; David Gilmour; Wendy House; Jonathan Kaplan; Michael Landy; Vicki Lewis; Helen van der Meij; Lucia Nogueira; Anthony Reynolds; Bridget Smith; Digby Squires; Sarah Staton; Jon Thompson; Gillian Wearing; Jack and Nell Wendler; Richard Wentworth; and everyone at Delfina Studios.

The Henry Moore
Foundation